Richard Thomson

Vincent
van Gogh
The Starry Night

THE MUSEUM OF MODERN ART, NEW YORK

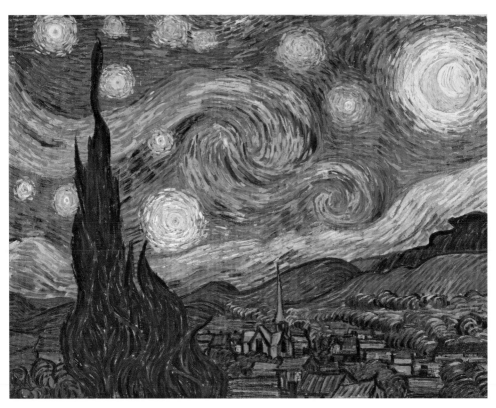

FIG. 1. Vincent van Gogh. *The Starry Night*.
1889. Oil on canvas, 29 × 36 ¼" (73.7 × 92 cm).
The Museum of Modern Art, New York.
Acquired through the Lillie P. Bliss Bequest

The Starry Night

WITHOUT DOUBT, VINCENT VAN GOGH'S PAINTING *THE STARRY NIGHT* (FIG. 1) is an iconic image of modern culture. One of the beacons of The Museum of Modern Art, every day it draws thousands of visitors who want to gaze at it, be instructed about it, or be photographed in front of it. The picture has a far-flung and flexible identity in our collective *musée imaginaire*, whether in material form decorating a tie or T-shirt, as a visual quotation in a book cover or caricature, or as a ubiquitously understood allusion to anguish in a sentimental popular song. *Starry Night* belongs in the front rank of the modern cultural vernacular.

This is rather a surprising status to have been achieved by a painting that was executed with neither fanfare nor much explanation in Van Gogh's own correspondence, that on reflection the artist found did not satisfy him, and that displeased his crucial supporter and primary critic, his brother Theo. *Starry Night* was painted in June 1889, at a period of great complexity in Vincent's life. Living at the asylum of Saint-Rémy in the south of France, a Dutchman in Provence, he was cut off from his country, family, and fellow artists. His isolation was enhanced by his state of health, psychologically fragile and erratic. Yet for all these taxing disadvantages, Van Gogh was determined to fulfill himself as an artist, the road that he had taken in 1880. The letters that he wrote in 1889, in the weeks and months preceding and following the painting of *Starry Night*, demonstrated his highly engaged understanding of art: in terms of his own picture-making practice, and in relation to the contemporary artists whom he admired and the art of the past that he revered. Van Gogh's thinking—whether articulated pictorially in paintings and drawings or verbally in correspondence—was fixated on art.

During the summer and fall of 1889 Van Gogh was deeply concerned with style. This was the word he used in his correspondence, and it had many ramifications for him. Style touched not only the appearance of his paintings, how they were crafted and colored, his own personal handwriting of touch and texture in response to his motif, but also what they represented and how—even where and under what conditions—they should be made. Vincent's conscious grappling with problems of style and method was played out in his work, and his alternating experiments with pictures done in front of nature and from the imagination were means of resolving them in practice. He also made replicas of canvases that he felt had been successful and, particularly in the later part of the year, made painted copies of the black-and-white prints Theo sent him after artists he admired—among them Rembrandt, Eugène Delacroix, and Jean-François Millet—by painting variations that added his own interpretative color to their original compositions. If by copying Van Gogh maintained a stylistic dialogue with past art, his conversation with his contemporaries in the avant-garde seems to have been constant in his own mind. This is apparent in his letters to Theo, in which what Vincent imagines Paul Gauguin and Emile Bernard are doing in their current work is constantly if speculatively invoked. It surfaces too in the practical decisions he made about whether or not to exhibit in Paris with Gauguin's group in its renegade exhibition at the Café Volpini on the site of the grand Universal Exhibition staged that summer, or what to exhibit at the Salon des Indépendants in September.

Whether it was negotiating his position in the Parisian avant-garde at a distance of four hundred miles or deciding what to paint in the landscape at Saint-Rémy, Van Gogh's incessant and self-critical deliberation about artistic practice and strategy marks him out as an artist determined to identify and articulate his own style, a term that had another dimension for him. For another word that occurs frequently in his correspondence during this period is consolation. By this Vincent seems to have meant both the cathartic satisfaction of crafting a harmonious work of art and the sense of intimate communication that the work secures between artist and spectator.[1] *Starry Night*

should be considered in such contexts, and placed squarely within the ambitions, anxieties, and achievements of an extraordinary artist making work in demanding isolation.

The journey that had made Vincent van Gogh an artist and had led him to Saint-Rémy was a long and convoluted one.[2] Born in 1853, the son of a Protestant pastor in the southern Netherlands, at seventeen he had followed his successful uncle Vincent into the firm of Goupil, one of the leading art dealers of the period, with branches in several European cities. Having worked for the company in The Hague, London, and, briefly, Paris, in 1876 Van Gogh, increasingly preoccupied with religion, left the art trade, first to work as a teacher in England, then to study theology in Amsterdam, and next to work as a missionary among the miners of the Belgian coalfields. Sacked for overzealousness, in 1880 Vincent decided to train himself to be an artist, and his younger brother Theo, by now himself employed by Goupil in Paris, agreed to subsidize this new vocation. Although Van Gogh henceforth devoted himself single-mindedly to art, he remained deeply marked by his Christian heritage, seeking in unorthodox and conflicted ways to engage his life and work with moral values, such as honesty and brotherhood, yet bringing himself into conflict with the conservative certainties of his father. After five years working in his native Netherlands, Vincent, look-ing to improve his drawing, traveled first to Belgium, where over the winter of 1885–86 he worked at the Academy of Fine Art in Antwerp, and then in March 1886 to Paris. During his two years in the French capital his work developed dramatically. Having access to the richness of the Paris museums and the diversity of its art market, studying at the teaching studio of Fernand Cormon—where he met younger artists such as Louis Anquetin, Henri de Toulouse-Lautrec, and Bernard—collecting Japanese prints, and becoming increasingly engaged with a new generation of artists and dealers that he characterized as the *petit boulevard*, differentiating them from the more established artistic circles of Paris's central boulevards; all these opportunities contributed to his artistic progress. His color in particular became brighter and his

touch more varied. But Van Gogh found the metropolis frantic and debilitating, and in February 1888 he decamped southward for Arles, a small historic city on the banks of the river Rhône, some thirty miles from the Mediterranean coast of France.

Arles appealed to Van Gogh. With its population of 23,000 it was congenial in scale, and he found friends: the postal clerk Roulin (FIG. 2) and the café proprietor Ginoux. While the town provided motifs, such as public thoroughfares, cafés, and parks, the outlying countryside offered a contrast, its high-intensity agriculture on the flat, canalized plain of La Crau suggesting welcome analogies with Vincent's native Netherlands and the fantasy vision of Japan he had derived from the study of ukiyo-e prints. At the same time the strong sun and fierce heat of the southern climate presented him with new practical challenges, the sunlight encouraging him to intensify his color range and the winds of the mistral, the powerful wind that blows south down the Rhône valley, making work outdoors sometimes very difficult. If at first working alone at Arles allowed Vincent the opportunity to gradually absorb into his own practice the lessons about variegated touch, simplified drawing, and complementary color he had learned in Paris, he came to yearn for artistic exchange and was relieved when in October Gauguin, sponsored by Theo, came to share his accommodation. After two months, however, their relationship had splintered. Their differences varied from the banally domestic—Gauguin was tidy, Van Gogh chaotic—to the professionally

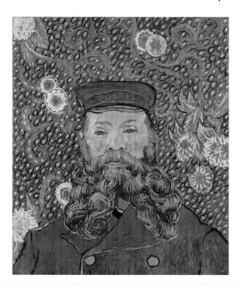

FIG. 2. Vincent van Gogh. *Portrait of Joseph Roulin.* 1889. Oil on canvas, 25 ⅜ × 21 ¾" (64.4 × 55.2 cm). The Museum of Modern Art, New York. Gift of Mr. and Mrs. William A. M. Burden, Mr. and Mrs. Paul Rosenberg, Nelson A. Rockefeller, Mr. and Mrs. Armand P. Bartos, The Sidney and Harriet Janis Collection, Mr. and Mrs. Werner E. Josten, and Loula D. Lasker Bequest (all by exchange)

artistic, in both matters of taste—
Gauguin admired Ingres and Edgar
Degas, Van Gogh Delacroix and
Adolphe Monticelli—and of prac-
tice. For Gauguin favored painting
with flat surfaces and woven
textures, Van Gogh palpable
facture and complementary colors;
above all, Gauguin had recently
begun to insist upon working from
memory and imagination, while
Van Gogh found it very hard to
paint without his subject in front
of him, however much he might
exaggerate form and color. The rift,
when it came, either caused or was
exacerbated by a psychological
crisis for Van Gogh, during which
he mutilated his left ear (FIG. 3).

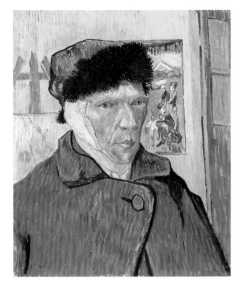

FIG. 3. Vincent van Gogh. *Self-Portrait with Bandaged Ear.* 1889. Oil on canvas, 23 ¹³⁄₁₆ × 19 ¹¹⁄₁₆" (60.5 × 50 cm). The Samuel Courtauld Trust, Courtauld Institute of Art Gallery, London

While this may not have been the first manifestation of his condition—
Van Gogh had consulted a psychologist in The Hague around 1879–80—
and we may never have an exact diagnosis (acute intermittent porphyria,
epilepsy, alcoholism, and hereditary factors have all been suggested),
the incident in late December 1888 started the spiraling cycle of length-
ening and incapacitating crises interspersed with periods of stability
and work that ultimately led to Van Gogh's suicide at Auvers-sur-Oise
in July 1890.

Having spent the early months of 1889 in the public
hospital at Arles, Van Gogh decided voluntarily to enter himself into
the asylum at Saint-Rémy, some fifteen miles to the northeast.[3] Saint-
Rémy was then a modest little town of fewer than 6,000 inhabitants. To
the north the flat terrain between the Rhône and Durance rivers stretches
a dozen miles northward to the great medieval city of Avignon, and Saint-
Rémy itself is situated on a long slope that leads up from this plain to
the dramatic rocky peaks of the Alpilles, or little Alps, an independent

range of small but craggily crenellated hills to the south of the town. The asylum of Saint-Paul-de-Mausole (FIG. 4), a well-established institution run by Dr. Auguste Peyron, was accommodated in a complex of

FIG. 4. Advertisement for Saint-Paul-de-Mausole asylum

former ecclesiastical buildings—comprising housing blocks, a church, and a large enclosed garden—at the very foot of the Alpilles and about a mile's walk downhill to the town. Van Gogh entered it on May 8. At the asylum Vincent was given supervision, regular meals, and some treatment—essentially hydrotherapy; he took a two-hour bath twice a week—but he chose not to ask Peyron about his condition or progress. Above all, staying at the asylum was intended to provide the artist with a haven of tranquillity.

Van Gogh's work at Saint-Rémy had to accept certain restrictions. Some were imposed by the asylum's regime. To begin with, Peyron kept Vincent under observation, and initially he was only allowed to paint and draw within the confines of the institution. On May 26 Peyron wrote to Theo in Paris that he was now prepared to allow the painter into the surrounding countryside.[4] However, he never seems to have worked more than a few hundred yards from the asylum and it is likely that he was always accompanied, as was the case when he walked down to Saint-Rémy in early June, when he found being among many people disturbing.[5] Other limitations were enforced by his state of health. For the first two months—during which time he executed *Starry Night*—Van Gogh was stable and Peyron was content with his progress. However, about July 16 he suffered another crisis, and was incapacitated for about five weeks. This alternating pattern of stability and distress lasted until Van Gogh left Saint-Rémy for Paris, and then for Auvers, on May 16, 1890. Further limitations the artist chose for himself. He did not paint his fellow patients, except as schematic figures in paintings of the gardens, although he made portraits of

one of the warders and his wife. (The copying of works by other artists that Vincent began in fall 1889 was in part to sharpen his drawing of the figure.) He also opted to ignore the remains of Glanum, a Roman town replete with triumphal arch within a couple of minutes' walk from the asylum, just as in Arles he had paid no close attention to the great Romanesque church of St. Trophime. Essentially, these various limitations restricted Van Gogh's range of subjects: few portraits, still lifes, copies, only the localized landscape, rarely ventured social subjects such as the streets of Saint-Rémy. But—to use contemporary painters' terms—if he was limited in terms of *sujet* (subject), he could still explore *effet* (conditions of weather or light).

One *effet* that had interested Van Gogh at Arles was night. He had undertaken nocturnal effects before; for example, the *Potato-Eaters*, painted in May 1885 prior to leaving The Netherlands, represented a family of peasants eating their evening meal in a dark room illuminated by lamplight. But at Arles the idea of painting the night sky became a haunting one. A couple of months after arriving in Arles, on April 9, 1888, he wrote to Theo that "I must also have a starry night with cypresses, or perhaps above all a field of ripe corn; there are some wonderful nights here."[6] However, it was not until the end of the summer that he began to accumulate canvases of nocturnal subjects. They form a somewhat hybrid group, including two sunset scenes of men unloading barges on the banks of the Rhône (FIG. 5), a portrait of the Belgian painter Eugène Boch with a background of a star-filled sky (FIG. 23), the gas-lit interior of the Café de la Gare (FIG. 6), adjacent to the yellow house where Vincent lodged, and a café terrace in the Place du Forum, in the center of Arles (FIG. 9). This burst of activity produced a varied group mixing both *sujet*—landscape, portrait, interior, townscape—and *effet*—sunset, gas illumination, and the combination of gaslight and natural nocturnal illumination.

Within this cluster of canvases was a painting, now known as *Starry Night, Arles* (FIG. 7), about which Vincent reported to Theo about September 29: "Enclosed is a little sketch of a square size 30 canvas, the starry night actually painted at night under a gas jet. The sky is greenish-blue, the water royal blue, the ground mauve. The town

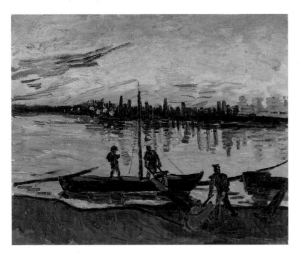

FIG. 5. Vincent van Gogh. *The Stevedores in Arles*. 1888.
Oil on canvas, 21 ¼ × 25 %₁₆" (54 × 65 cm). Museo Thyssen-
Bornemisza, Madrid

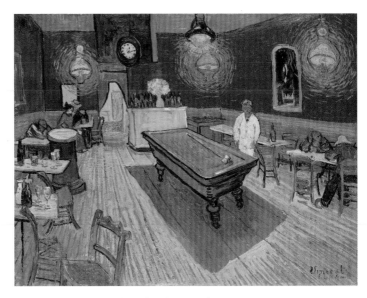

FIG. 6. Vincent van Gogh. *The Night Café*. 1888. Oil on
canvas, 28 ½ × 36 ¼" (72.4 × 92 cm). Yale University Art
Gallery, New Haven, Connecticut. Bequest of Stephen
Carlton Clark, B.A. 1903

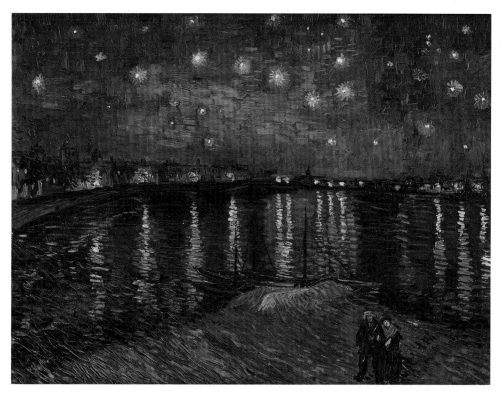

FIG. 7. Vincent van Gogh. *Starry Night, Arles.*
1888. Oil on canvas, 28 9/16 × 36 ¼" (72.5 × 92 cm).
Musée d'Orsay, Paris

is blue and violet, the gas is yellow and the reflections are russet-gold down to greenish bronze. On the blue-green expanse of sky the Great Bear sparkles green and pink, its discreet pallor contrasts with the harsh gold of the gas. Two colorful little figures of lovers in the foreground." He continued: "And it does me good to do difficult things. That does not prevent me from having a terrible need of—shall I say the word—religion? Then I go out at night and paint the stars....I should not be surprised if you liked the *Starry Night* and the *Ploughed Fields*, there is a greater quiet about them than in the other canvases." Later in the same letter, having discussed Gauguin and Bernard as well as drawing figures from memory (a practice those two were currently pursuing in Brittany), he went on: "As for the *Starry Sky*, I'd still very much like to paint it, and perhaps one of these nights I shall be in the same ploughed field if the sky is sparkling." He then mentioned Leo Tolstoy's book *My Religion*, translated into French in 1885, and its lack of belief in resurrection.[7]

 This letter reveals many things, including Van Gogh's multilayered and associative thinking. He was evidently satisfied with *Starry Night, Arles*, showing the lights of Arles along the arcing banks of the Rhône. He was pleased that he had executed it *sur le motif*, his preferred practice, but he was apparently being ingenuous about this. His view of Arles looks southwestward, but the Great Bear, which is so central to his painted sky, should be in the north.[8] It seems that the painting amalgamates an observed townscape with a contrived firmament. The letter also cagily links the starry sky with religion. Van Gogh was not specific here, and religion was a fraught subject for him, which he could neither fully accept nor totally abandon. But his use of the word "quiet" and the reference to Tolstoy's ideas suggest that the night sky evoked in him—as it does in many of us—emotions of calm and notions of infinitude. In particular, Van Gogh explained that the subject, which he linked with the countryside, still fascinated him, and that it could still bear fruit.

 Van Gogh's interest in night paintings was far from exceptional. Nocturnal subjects have a long tradition in European painting, not least in seventeenth-century Dutch art in the work of

Rembrandt and others. But in the decade immediately preceding Van Gogh's paintings of 1888 and 1889 the subject was quite common on the Paris art scene, the lodestar to which Van Gogh had been attracted since his days in the trade. It occurred in subject pictures shown at the major annual Salon exhibition, in works such as *Rest on the Flight into Egypt* exhibited by Luc-Olivier Merson in 1879 or Hippolyte Berteaux's 1884 *La Jeune Pastoure*, with its quotation from the historian Henri Martin's *Enfance de Jeanne d'Arc*: "For hours at a time, she plunged her eyes in the depths of the starry sky."[9] More independent *grand boulevard* artists, respected by the younger generation, showed night pictures with dealers like Georges Petit, among them Jean-Charles Cazin and especially James McNeill Whistler, with his highly reductive nocturnes. In particular, the night subject was one that engaged younger painters of the Parisian avant-garde. At the Salon des Indépendants in May 1887, Charles Angrand, with whom Vincent had exchanged canvases, exhibited *The Accident*, a nocturnal crowd scene in neo-impressionist touch. Later that year Louis Anquetin painted the canvas he showed with the enterprising Brussels group Les XX in February 1888 as *Rue (Soir – 5 heures). Ebauche [Avenue de Clichy]* (FIG. 8). This was an experiment in his new "cloisonist" manner, the twilit street scene depicted in strong bounding contours and with the color reduced to a simplified chromatic harmony of deep blue and orange-yellow. Van Gogh had known Anquetin via Cormon's studio, and must have seen this canvas, because the Arles *Terrace of a Café* (FIG. 9) is Vincent's pictorial digestion of Anquetin's prototype. The last thing Van Gogh had done prior to taking the train to Arles on February 19, 1888, had been to visit Georges Seurat's studio, where he would have seen *Parade de cirque* (FIG. 10) ready to be displayed at that year's Indépendants.

FIG. 8. Louis Anquetin. *Rue (Soir – 5 heures). Ebauche [Avenue de Clichy]*. 1887. Oil on paper and canvas, 27 ⅛ × 21" (68.9 × 53.3 cm). Wadsworth Atheneum Museum of Art, Hartford, Connecticut. The Ella Gallup Sumner and Mary Catlin Sumner Collection Fund

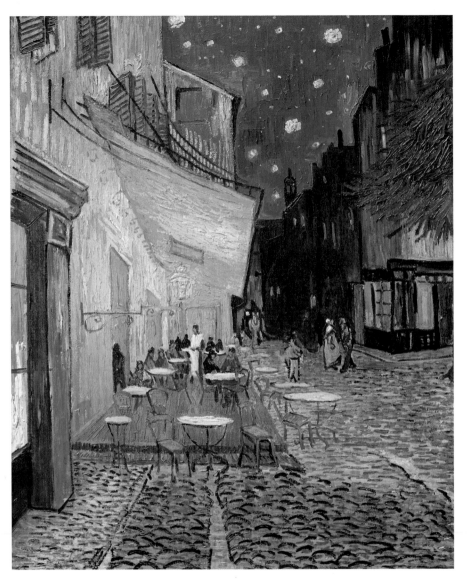

FIG. 9. Vincent van Gogh. *Café-terrace at Night.* 1888. Oil on canvas, 31 ¾ × 25 ¹¹⁄₁₆" (80.7 × 65.3 cm). Kröller-Müller Museum, Otterlo, The Netherlands

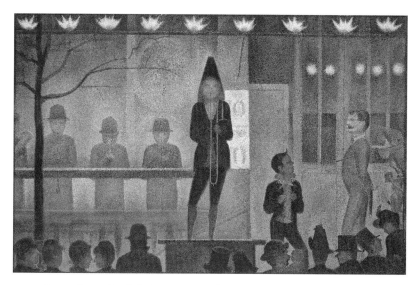

FIG. 10. Georges Seurat. *Parade de cirque*. 1887–88. Oil on canvas, 39 ¼ × 59" (99.7 × 149.9 cm). The Metropolitan Museum of Art, New York. Bequest of Stephen C. Clark, 1960

A multifigure composition of the queue for a traveling circus being entertained outside its tent, this work is an ambitious yet subtle engagement of Seurat's neo-impressionist technique with the complex demands of representing gas illumination at night. Seurat, then the leading artist of the Parisian avant-garde, was much admired by Van Gogh, who told Theo shortly after seeing *Parade* that "it would be good to have a painted study of his."[10] The two brothers did own a Seurat drawing, a night scene of a *café-concert* from 1886–87. Advanced painters' commitment to the subject continued while Van Gogh was in Provence. Vincent and Theo decided to submit *Starry Night, Arles* to the Indépendants in September 1889, and Theo—knowing his brother's own interests—reported that another member of the neo-impressionist group, Louis Hayet, had a nocturne of the Place de la Concorde on view.[11] That Van Gogh should return to the theme at Saint-Rémy was no surprise, for even at four hundred miles' distance it kept him parallel to his Parisian peers.

Following his admission to the asylum at the beginning of the second week of May 1889, Van Gogh took advantage of his confinement to explore the institution's interior spaces and gardens, sounding out his new circumstances. His early letters to Theo describe these explorations, and their mention of the highly disturbed states of some of the other patients reminds us of the difficult atmosphere in which Van Gogh had elected to live and work, conditions that must have increased his sense of isolation. Nevertheless, he gamely articulated his diverse artistic preoccupations. In a letter probably written on June 2 he opined that "I have gradually come to believe more than ever in the eternal youth of the school of Delacroix, Millet, Rousseau, Dupré and Daubigny as much as in that of the present." He went on to link his admiration for those mid-century artists around whose work his taste had been formed in his art-dealing youth to his immediate state of mind: "This morning I saw the country from my window a long time before sunrise, with nothing but the morning star, which looked very big. Daubigny and Rousseau have done just that, expressing all that it has of intimacy, all that vast peace and majesty, but at the same time adding a feeling so individual, so heartbreaking. I have no aversion to that sort of emotion." Vincent continued that he had read Emile Zola's *Le Rêve*, a novel about religious visions and youthful passions of equal intensity published in October 1888, that he would be happy for *Starry Night, Arles* to be submitted to the next Indépendants, and that the mistral was not as fierce as by the river at Arles.[12]

Shortly after this letter, Van Gogh was allowed to work in the immediate vicinity of the asylum. In a letter written a week later he explained that "I have been out for several days, working in the neighborhood." This had produced two landscapes, one of which—if painted out-of-doors—nevertheless effectively represents what "I see from the window of my bedroom. In the foreground, a field of wheat ruined and hurled to the ground by a storm. A boundary wall and beyond the gray foliage of a few olive trees, some huts and the hills. Then at the top of the canvas a great white and blue cloud floating in the azure" (FIG. 11).[13] Among the other landscapes he produced shortly thereafter was one definitely painted outside the asylum's precincts,

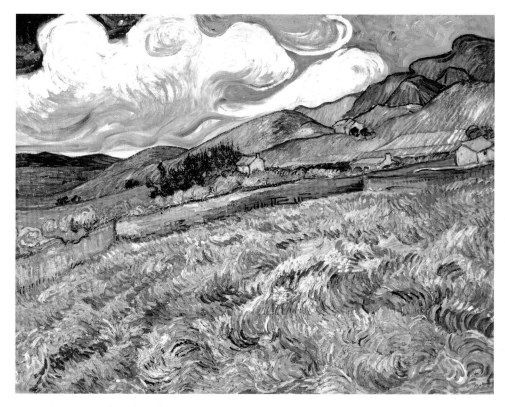

FIG. 11. Vincent van Gogh. *Landscape from Saint-Rémy.*
1889. Oil on canvas, 27 ¾ × 34 ¹³⁄₁₆" (70.5 × 88.5 cm).
New Carlsberg Glyptotek, Copenhagen

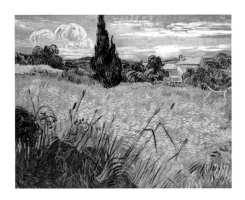

FIG. 12. Vincent van Gogh. *Green Wheat*. 1889.
Oil on canvas, 28 ¾ × 36 ⁷⁄₁₆" (73 × 92.5 cm). National
Gallery, Prague

which Van Gogh described in a letter of June 16 to his sister Wil: "A field of wheat turning yellow, surrounded by blackberry bushes and green shrubs. At the end of the field there is a little house with a tall somber cypress that stands out against the far-off hills with their violet-like and bluish tones" (FIG. 12).[14] These canvases have a vitality, a freshness of observation, that bespeaks Van Gogh's enthusiasm to be able to work freely within nature once again.

Only a day or two later Vincent wrote to Theo. Fourteen months after he had imagined a starry night with cypresses he had made the picture. "*Enfin*, I have a landscape with olive trees [FIG.13] and also a new study of a starry sky [FIG. 1]. Though I have not seen Gauguin's and Bernard's last canvases I am pretty well convinced that these two studies I've spoken of are parallel in feeling," he wrote. "When you have looked at these two studies for some time...it will perhaps give you some idea, better than words would, of the things that Gauguin and Bernard and I used to talk about...; it is not a return to the romantic or to religious ideas, no. Nevertheless, by going the way of Delacroix, more than is apparent, by color and more spontaneous drawing than delusive precision, one could express the purer nature of the countryside compared with the suburbs and cabarets of Paris." He and his two friends, he concluded, produced work that might "give consolation or...prepare the way for painting that will give even greater consolation."[15] At no point did Van Gogh say more about the genesis of *Starry Night* than in this letter of June 17 or 18.

In practical terms the painting had three immediate stimuli. One was observation of nature, looking at the predawn night sky as he had described in the letter right at the beginning of the month. Such observation was limited to what Van Gogh could see through the

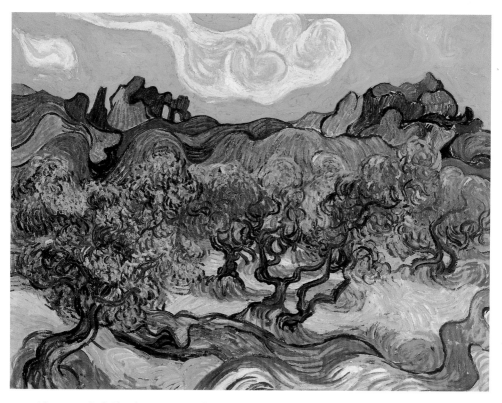

FIG. 13. Vincent van Gogh. *The Olive Trees*. 1889. Oil on
canvas, 28 ⅝ × 36" (72.6 × 91.4 cm). The Museum of Modern Art,
New York. Mrs. John Hay Whitney Bequest

bars of his bedroom window; as an inmate of an asylum he would not have been allowed out at night. The second was his own paintings. Finally determined to execute the long dreamed-of canvas sometime between June 16 and 18, and unable to work outside in front of what he was painting, as he preferred, he had recourse to his own recent work. For *Starry Night* lifts elements from the pictures made in the second week of the month and described to Theo and Wil. The tumbling profile of the hills to the right was borrowed quite directly from the motif of the walled enclosure of storm-damaged corn (FIG. 11), while the canvas of the wheat field (FIG. 12), Vincent's first Saint-Rémy canvas in which he gave the cypress pride of place, rather more loosely suggested the salient tree. The third stimulus seems to have been a drawing. This was a modest but quite detailed panorama of

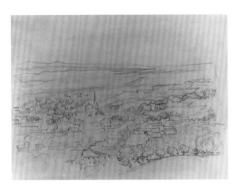

FIG. 14. Vincent van Gogh. *View of Saint-Rémy*. 1889. Pencil on wove paper, 9 ⅜ × 12 %₆" (23.8 × 31.9 cm). Courtesy Van Gogh Museum, Amsterdam

Saint-Rémy made in pencil in a sketchbook (FIG. 14). We do not know exactly when the drawing was done, but it has the character of a visual inventory, the sort of notation an artist might make upon arriving in a new locale, taking in the broad view. Sketched from the slope above the town, not far from the asylum, the drawing may well have been made when Van Gogh was first allowed out, a stock-taking reconnaissance looking north toward Avignon. Thus *Starry Night* was a *paysage composé*, to use the conventional term: painted from the imagination in the studio, from preliminary studies and observations made in nature.

Starry Night was painted on a standard size 30 canvas, 75 by 92 centimeters, which may have been commercially acquired. The surface was prepared with an off-white priming. This is visible all over the canvas: in the sky, the landscape, the mountains, and the trees. Van Gogh's active

use of the underlayer suggests not only that the painting was executed quite swiftly—perhaps in two or three sessions, with some drying time in between—but also that he approached it with great confidence, for the subtle but overall intrusion of the pale surface gives the whole picture a unity as well as a quality of space and light.[16] It gently counterpoints the deep blues and greens that dominate the picture, at the same time linking with its lightness the linear flow of fatter strokes that lie over it. Without this purposeful integration of the underlayer the paint surface would have been too dense, without breath. Van Gogh knew this from the outset. Further evidence of rapid execution comes in the sky, which was painted wet on wet, one color applied next to another before the former had dried. Mid-blue seems to have been applied first, in the swirls, with the darker blue and blanched mid-greens later. Above and below those twisting central shapes the paint was applied in quite ordered, roughly horizontal strokes, becoming more restless to the right.

As Van Gogh painted in the sky he left reserves—spaces in the paint layer—for the stars to be added, again confidently making decisions as he applied the colors, without it seems any recourse to a preparatory drawing of the composition, which was drafted straight onto the canvas. Only the star to the right of the tree-top was added over initial horizontal touches. Although the stars generally have dull yellow centers, sometimes surrounded by a white circle or topped off with an orange dot, their auras are varied. The star to the top of the tree is simply an orange disc with a pale blue aura, whereas the large one to center left has yellow in the middle, the colors shifting out into pale greens and white, with pale forget-me-not blue at the edges (FIG. 15). The moon is a thickly applied orange crescent, surrounded by a pale yellow-green that drifts into a circular glow in duck-egg blue. The cypresses—a tall one and perhaps two shorter ones—were also intended from the outset. Their palette was sparing: dark green, brown, and a deep aubergine-violet, the three colors being applied almost simultaneously. One wonders if Van Gogh had not preordained these colors for the trees, the simple choice allowing less delay in decision-making as he worked. The hills were brushed in the

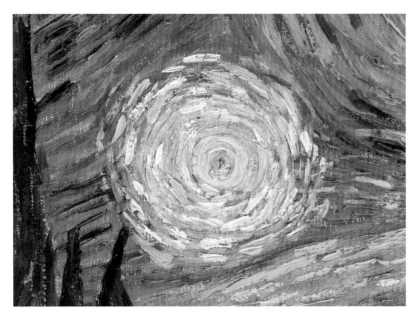

FIG. 15. Detail of *The Starry Night*

FIG. 16. Detail of *The Starry Night*

same dark and lighter blues as the sky above, but the outlining of their contours—for instance the ridge on the right—was redrawn later as he tidied the design. Below that ridge the middle ground was picked out in olive green, repeated in the central hillside and the foliage to the left of the cypresses, thus linking the middle space. The trees around the village were added in a series of concertina-like half-loops, their dark and blue greens overlaid with a peppermint green to suggest the *effet* of moonlight. Toward the center of the painting the buildings were blocked out in schematically descriptive rectangular shapes, with illuminated windows in dull yellow, orange, and sharp green, and an oxblood red on a roof left of the church. To the right, however, the houses become even more summary, the walls and roofs indistinguishable: again a sign of speedy execution. Indeed there is one passage—at the center of the bottom edge—which is painted in parallel strokes of brown, pale and dark blue, and rich mid-green, that acts as little more than a painted patch filling space (FIG. 16). Next to it the placing of houses one in front of the other offers a sense of recession, which is echoed by the lines of trees, but the village is not organized into streets.

In chromatic terms *Starry Night* is a harmony in blue, offset by the complementary orange of the astral bodies. But that binary relationship, rendered subtle by the counterpoint of greens and browns, was an appropriately simple chromatic structure for the task Van Gogh had set himself: to paint the deeply somber but rich and elusive colors of the night. These chromatics match the quite direct character of the composition. The vertical relationship of the tallest cypress close to the spectator and the church steeple in the middle distance inserts a diagonal that creates space within the center of the canvas at the same time that it provides two vertical accents. And the clump of climbing cypresses to the left acts as a stabilizing balance to the diminuendo of the hills that tumble from right to left. *Starry Night* may have been painted quickly, but it was executed with startling confidence and surety, and it achieves an extraordinary compositional balance essential to the containment of the great forces that it evokes.

Seen as a whole, *Starry Night* would look quite a straightforward, if schematic, image of landscape and sky were it not for

the arcing, dipping, swirling shapes contesting the center of the canvas. They create a compositional crescendo, a formal focus that is at once fascinating and extraordinary, pitched against the strongly realized spatial structure and yet echoing the rhythmic momentum of the brushstrokes that animate the whole canvas surface in a more minor key. How might we approach closer this great painting, with its surging forces, rich and resonant chromatics, and mysterious but suggestive shapes?

In the June 17 or 18 letter to Theo announcing *Starry Night*, Vincent, in his typically telegraphic and jumpy way, made a number of allusions. He associated himself with the new aesthetic of Gauguin and Bernard, with its emphasis on the rejection of the naturalistic representation of nature, but also lauded Delacroix's work in terms of color and drawing. This was consistent with the views expressed in the letter of about June 2, in which he had said that his admiration was increasingly returning to artists of mid-century such as Delacroix, Millet, and Rousseau. Isolated in the Saint-Rémy asylum, Van Gogh had to use his visual memory to invoke artistic allegiances and analogies that would sustain his work. That invocation, as his letter hints, was retrospective as well as contemporary. He greatly admired Delacroix's *Christ Asleep during the Tempest* (FIG. 17), which had been on view in Paris in 1886. This painting is characterized by the mature Delacroix's ceaselessly rhythmic brushwork, as apparent in the sky as in the water, and his intensity of color, nowhere more evident than in the yellow rays of the halo that curves over Christ's blue-cowled head, a chromatic arrangement similar to the constellations in *Starry Night*. Van Gogh also conjured up Rousseau's landscapes, as images of powerful emotion, and there is a type of Rousseau—such as *Sunset near Arbonne* (FIG. 18), which he might have seen in Paris in the 1870s—in which intense, all-encompassing illumination and restless brushing of shifting forms carry a strong emotive charge. Vincent also mentioned Millet, his paradigm of a modern artist, although Millet's own *Starry Night* (FIG. 19) is a canvas he probably never saw. Inventing his picture in the confines of his room

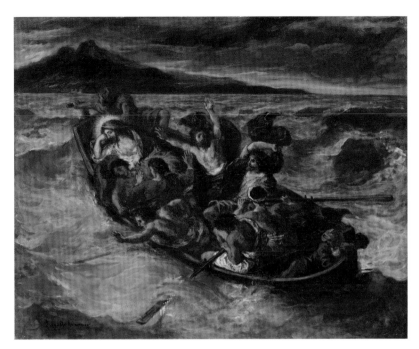

FIG. 17. Eugene Delacroix. *Christ Asleep during the Tempest.*
c. 1853. Oil on canvas, 20 × 24" (50.8 × 61 cm). The Metropolitan
Museum of Art, New York. H. O. Havemeyer Collection,
Bequest of Mrs. H. O. Havemeyer, 1929

in the asylum, Van Gogh could draw on his visual memory for distant, supportive associations.

The same letter also denies that *Starry Night* has any "romantic" or "religious" ideas. But this has not prevented later interpreters of the painting, aware of Van Gogh's processes of practice and thought, layered and associative, from imputing ideas. Vincent had long been a great reader. Many of the books that he had read—among them the Scottish historian Thomas Carlyle's *Sartor Resartus*, Charles Dickens's novel *Hard Times*, and the poetry of Henry Wadsworth Longfellow and Walt Whitman[17]—use the imagery of stars, but it would be imprudent to attribute to any particular text a literary trigger that would have fired off *Starry Night*. Often likely texts fail to link. Van Gogh had certainly read *Lettres de mon moulin* (1866), Alphonse Daudet's

volume of stories about his native Provence, several set, like Daudet's very windmill, within a few miles of Saint-Rémy. The collection even includes a story titled "Les Etoiles," but this pretty tale of unrequited love has nothing to do with Van Gogh's figureless painting. He had recently read Zola's highly romantic *Le Rêve*, but in the novel the dark starlit night is used as a repeated contrast to the virginal whiteness of the heroine Angélique's bedroom: again, hardly a relevant parallel.

Van Gogh's attitude to religion was consistently complex and contradictory. If, as we have seen, the experience of the night sky that led to the *Starry Night* he painted at Arles in September 1888 did arouse, somewhat shamefacedly, religious feelings, he denied them in relation to the Saint-Rémy painting. The 1889 painting has been interpreted both in terms of Jacob's dream (Genesis 37:9–11) and of the apocalyptic visions of St. John (Revelations 12:1–5), even as Van Gogh's own "Agony in the Garden."[18] But it is unlikely that Van Gogh, with his conflicted feelings about religion, would have made such allusions, even obliquely. We should take both his denial of religiosity and his repeated references to "consolation" at face value. For Vincent, consolation seems to have meant as much what the artist might put into a picture as how the painting might affect a viewer who was predisposed to respond to it. So consolation was a concept that involved both the calming, healing

emotion and some kind of dialogue between artist and spectator. It was thus a notion particularly appealing to a man struggling under conditions of psychological and social isolation. The extent to which *Starry Night* succeeded in these terms can be called into question because— as we shall see—the painting left Vincent dissatisfied and Theo unreceptive. Many of us respond to the night sky in the way Van Gogh did in his letter at the very beginning of June, when he spoke of being awed by its "vast peace and majesty," and such a common but profound feeling may well have formed some element of what Vincent here called consolation.

Van Gogh's fascination with the starry sky coincided with considerable advances in the science of astronomy and with them the burgeoning publication of popular texts explaining the stars. But we should be cautious of the temptation to link him too closely to this. The only specifically identifiable constellation in his paintings is the Great Bear in the Arles *Starry Night*. There are teasing analogies between the popular scientist Camille Flammarion's notion that the great figures of history such as Jesus, Buddha, Newton, and Galileo are reincarnated on distant stars and Van Gogh's own musing that the great artists of the past are still working "on other orbs," but there is no evidence that the artist had read any of Flammarion's texts and such speculations were run-of-the-mill whimsies in an age whose faith in scientific progress was countered by a fascination with ectoplasm and Ouija boards.[19]

According to computer modelling of the night skies above Saint-Rémy on June 16–18, 1889, the moon was gibbous, between its full and third quarter, and thus ovoid in shape, rather than the crescent Vincent painted (FIG. 20). Venus was the morning star, and might thus correspond to the brightly haloed form to the right of the cypresses. But the other stars he painted are only approximations, aspects of what would have been in the sky over a period of a month or so assembled according to no astronomic rationale. What about the great swirls to the center? They are unlikely to represent the Milky Way, which would have been low in the sky on those early dawns. Van Gogh may have had some general knowledge of spiral nebulae, but the most

likely hypothesis may be that both the pale band along the horizon and the eye-catching swirls represent cloud banks, the latter depicted as strikingly spiraled by the twisting winds (FIG. 21).[20] Van Gogh's instincts were primarily visual. Any oblique linkage *Starry Night* may have had with popular science is more likely to have been pictorial, perhaps through sky maps in illustrated books he might have seen rather than texts we have no evidence he had read (FIG. 22). After all, his response to the night sky above the Mediterranean on a visit to Saintes-Maries-de-la-Mer in early June 1888 had been emphatically painterly. "The deep blue sky was flecked with clouds of a blue deeper than the fundamental blue of intense cobalt, and others of a clearer blue, like the blue whiteness of the Milky Way" he told Theo. "In the blue depth the stars were sparkling, greenish, yellow, white, pink, more brilliant, more sparklingly gemlike than at home." Vincent repeated this to Wil three months later, insisting that to paint white dots on a dark background simply would not suffice.[21] Looking at *Starry Night* via literature, religion, and science, all of which contributed to the rich associative loam of Van Gogh's mind, takes us only so far. We must return to the visual evidence of the painting itself.

Starry Night has two overriding features to its pictorial orchestration: color and rhythm. Van Gogh's own observations of the Provençal night—by the Rhône, on the Mediterranean shore, through the bars of the asylum window—showed him that color, above all the deep registers of blue, was the crux. He also knew, in his isolation, that the night pictures being painted in Paris by Seurat, Angrand, Anquetin, and others were all predicated on chromatic solutions. Blue was one of the colors that had a particular suggestiveness for Van Gogh. Of the background of his portrait of Boch in August 1888 he said: "I paint infinity, a plain background of the richest, intensest blue that I can contrive, and by this simple combination of the bright head against the rich blue background, I get a mysterious effect, like a star in the depths of an azure sky" (FIG. 23).[22] Blue for Van Gogh evoked "infinity," by which he probably meant the spiritual notion of eternity as much as pictorial or physical space. Offset against brightness—whether the flesh tones and ocher jacket of the Boch portrait or the sharp citron

FIG. 20. Detail of *The Starry Night*

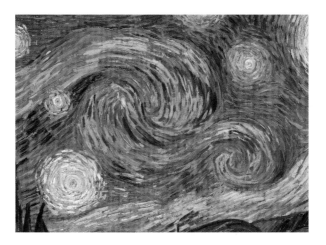

FIG. 21. Detail of *The Starry Night*

FIG. 22. Ernest Guillemin. *Le ciel de l'horizon de Paris (côté sud) vu à minuit le 20 juin.* Chromolithograph, 6 ¾ × 9 ⅞" (17 × 25 cm). Bibliothèque nationale de France

yellows and arresting orange accents of *Starry Night*—blue created for his eye a sense of the chromatically unsettling and thus emotionally evocative, a jarring of the harmony that stimulated a sense of the strangeness of experience.

Coupled with color was rhythm. The rather rectilinear treatment of the village in *Starry Night* is the only element that contradicts the pulsing forms that surround it, and one is drawn back to Van Gogh's insistent theme in his letters that the night picture was quintessentially a country picture. It seems that for him the silence and inactivity of the night enhanced one's sensibilities to the great forces of nature, untroubled by the petty intrusions of humankind. Although in *Starry Night* the eye is drawn to the stars haloed and gleaming in the infinite blue, it is also incessantly reminded of rippling terrestrial rhythms. These surge through the tumbling topography of the hills and pump through the undulating forms of the vegetation. The cypress trees in particular, climbing up the left side of the canvas, are drawn with dynamic, flowing strokes. The cypresses of this region form

compact, tight growths, and would only separate into flamelike tongues in high winds, the same that had ravaged the wheat fields he had painted (FIG. 24). This concurs with a reading of the central swirling shapes, and indeed the flowing forms along the horizon, as clouds under the propulsion of great gusts, made malleable by the mistral. If we choose to read *Starry Night* in these terms, as a pictorial realization of the great forces of nature, it enhances the reading of other key elements Van Gogh deployed. The cypress may typically be planted in Provencal cemeteries, but the purpose of that traditional association is that, as an evergreen, the tree suggests eternal life, not the more negative notion of death. This tallies with the dominant blue of the canvas, another evocation of the infinite. The painting seems like a celebration of natural energies, Van Gogh crafting his vigorous rhythmic forms and colors to suggest the constantly cyclic movements of nature—wind into calm, day into night, night into day, year into year. By pictorially articulating the energies he saw and sensed in nature, Van Gogh ordered his own creative forces, and in his processes of imagining and crafting *Starry Night* he perhaps found consolation.

 Starry Night is far from being a naturalistic picture. Van Gogh gave what is in reality a domed neoclassical church a pitched roof, contrived the horizon from a previous canvas, and invented the starscape.[23] Such an artificial compilation of *sujet* and *effet* was in many respects against his artistic principles. As he told Bernard in a letter of October 1888, his practice involved "arranging the color, enlarging, simplifying," but he still needed to work in front of his subject.[24] The working partnership with Gauguin would sunder primarily on that issue a couple of months later. Reflecting on those disputes in another letter to Bernard, written in late November 1889, Van Gogh referred to working from the imagination—or "abstraction" as he called

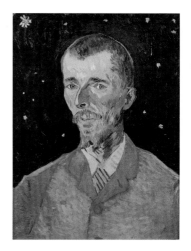

FIG. 23. Vincent van Gogh. *Eugene Boch (The Poet)*. 1888. Oil on canvas, 23 ⅝ × 17 ¾" (60 × 45 cm). Musée d'Orsay, Paris

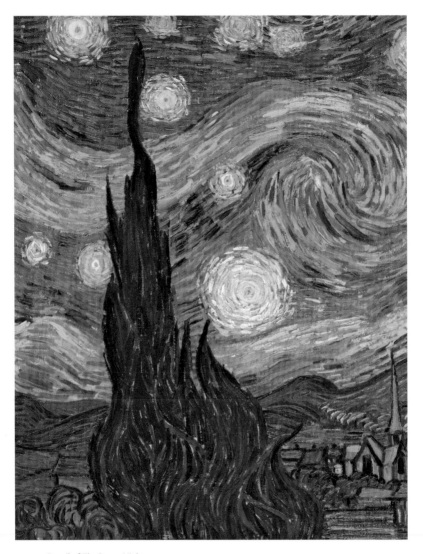

FIG. 24. Detail of *The Starry Night*

it—as dangerous "enchanted ground." "However," he continued, "once again I'm allowing myself to do stars too big, etc., new setback, and I've enough of that."[25] The tension between following his own instincts to work from nature and essaying pictures made from the imagination— like *Starry Night*—which kept him au courant with Bernard and Gauguin, told on Van Gogh.

The painting was one of nine canvases that Vincent sent in a batch to Theo on September 19. He described it in terms of a striving for style when he explained to his brother: "The *Olives* with a white cloud and a background of mountains [FIG. 13], as well as the *Moonrise* [FIG. 25] and the night effect [FIG. 1], are exaggerations from the point of view of arrangement, their lines are as warped as old wood-cuts." Admitting dissatisfaction with his work and heralding a turn to copying, Vincent identified "the *Olives* with the blue hills," which in his letter of June 17 or 18 he mentioned had been made at much the same time as *Starry Night*, as successful, along with other canvases he had painted *sur le motif*. "The rest"—and he implicitly included *Starry Night*— "tells me *nothing*, because it lacks individual intention and feeling in the lines."[26] Replying on October 4, Theo itemized the paintings he liked; they were ones done from nature.[27] *Starry Night* he passed in silence, having warned Vincent on June 14 that "the mysterious regions" of painting from the imagination might be treacherous in view of his brother's condition.[28] A month later he informed Vincent that painters in Paris such as Camille Pissarro and the Norwegian Erik Werenskiold admired the more descriptive *Starry Night, Arles*, shortly to be shown at the Indépendants. Theo's only reference to *Starry Night* was on October 22: "I understand quite well what it is which preoccupies you in your new canvases, like the village in the moonlight…, but I think that the search for some style is prejudicial to the true sentiment of things."[29]

Vincent replied to this critique that "in spite of what you said in your last letter, that the search for style often harms other qualities, the fact is that I feel strongly inclined to seek style, if you like, but by that I mean a more virile, deliberate drawing. I can't help it if that makes me more like Bernard or Gauguin."[30] This search for style had haunted Van Gogh throughout his time at Saint-Rémy, but he was

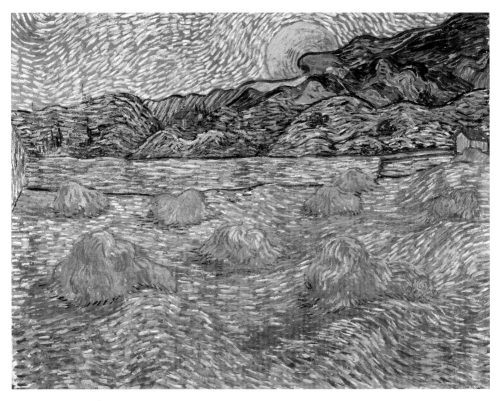

FIG. 25. Vincent van Gogh. *Landscape with Wheat Sheaves and Rising Moon.* 1889. Oil on canvas, 28 ⅜ × 36" (72 × 91.3 cm). Kröller-Müller Museum, Otterlo, The Netherlands

troubled about where and how to find it. When he painted *Starry Night*, in mid-June, there was a tension between working from nature and keeping up with Gauguin and Bernard. At the same time he was expressing his admiration for mid-century painters such as Delacroix, Millet, and Rousseau. Three months later, once Theo had seen the June canvases, the plan to make copies was drawing him to Delacroix and Millet, and yet the work of Gauguin and Bernard was still on his mind. These aesthetic tensions, which lasted throughout the summer, were entirely in Vincent's mind, and based on no practical example. He had seen none of Gauguin's work since the latter fled Arles in late December 1888. Their correspondence was modest, too, Vincent sending Gauguin only six letters in 1889 (the two from June and July are lost) and Gauguin five to Vincent.[31] Although Van Gogh had written Bernard no fewer than nineteen letters in 1888, there were only two in 1889, at the end of the year, one acknowledging photographs Bernard had sent of his work.[32] In other words, Van Gogh's dialogue with their work was largely imaginary, making assumptions about what it looked like. As it happens, their pictures looked very unlike *Starry Night*. Gauguin's imaginative watercolor *At the Black Rocks* (FIG. 26), made at Le Pouldu in southern Brittany in the summer of 1889, is closely contemporary to *Starry Night*, to which it bears some analogies in its blue tonality and spiraling shapes. But these are quite coincidental, for not only would Van Gogh have had no idea Gauguin had made this work but the schematic and metamorphic *At the Black Rocks* itself was quite extreme in Gauguin's current output.

Oddly enough, one can draw perhaps closer parallels between *Starry Night* and a canvas that Van Gogh never saw by an artist he admired but who did not feature in his articulated aesthetic debates in 1889. Seurat had painted *Port-en-Bessin, les grues et la percée* (FIG. 27) on the Normandy coast in 1888. This painting differs from the five others Seurat made that summer in that, while they are relatively descriptive, *Les grues* is unusually stylized in the rather regimented rippling of its evening clouds and the way they are echoed in the immediate foreground. Such a coincidence was entirely by chance, but both Seurat and Van Gogh were experiencing a tension between painting

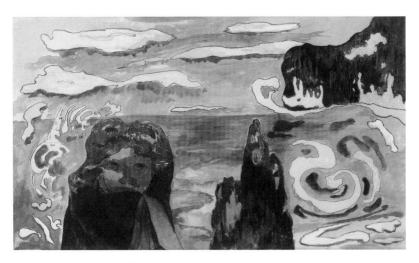

FIG. 26. Paul Gauguin. *At the Black Rocks*. 1889.
Watercolor and gouache with ink and metallic paint on
paper, 10 × 16" (25.3 × 40.6 cm). Private collection

that was still fundamentally descriptive and a new decorative styliza-
tion. The "*Moonrise*" picture that Van Gogh had also identified as one of
his stylistic "exaggerations" carries this decorative impulse further than
Starry Night. The golden harvest moon spills a pale light throughout the
sky and over the land, an aura that unifies the canvas and allows a
consistent, decorative surface, harmonized in rhythm.

 That search for style, which caused an unevenness in
the work of an artist as steady as Seurat and great pressures in that of
Van Gogh, is crucial to our understanding of *Starry Night*. Vincent
himself was hard on the picture. He made no replica of it, as he did at
this time with work that he thought particularly successful, although
he did recraft the composition in a drawing (FIG. 28). Here the cypresses
take on an even more urgent identity, while the swirling sky becomes
more coherent in its flowing contours. Vincent added another star as
well as smoke from the village chimneys, variations that allow more
play of the pen in the monochrome drawing, but to the detriment,
perhaps, of the structural control inherent in the painting. But it was
style that struck contemporary critics. In the only article published on

Van Gogh's work in his lifetime, Albert Aurier, writing in *Le Mercure de France* in January 1890, addressed himself to the dynamic, metamorphic qualities he saw in the recent paintings. Although generalizing, Aurier's remarks suggest pictures such as *Starry Night* in their evocation of "cypresses shooting up their nightmarish silhouettes of blackened flames; mountains arching their backs like mammoths or rhinoceroses." His hyperbolic prose, an encomium of Van Gogh's color and handling, concluded, slightly reserved, that he "sometimes, but not always, [achieves] the grand style."[33] The year after Van Gogh's suicide, reviewing the retrospective of his work at the 1891 Indépendants, Octave Mirbeau much more emphatically concluded that "Van Gogh had to a rare degree what differentiates one man from another: style."[34] Mirbeau, although only drawn to Vincent's work after the artist's death, was an important voice in Parisian art criticism around 1890, supporting innovative work. Mirbeau's current writing, such as his preface for Claude Monet's joint retrospective with Auguste Rodin in June 1889, typically lauded landscape painters' pantheistic embrace of the energies and fullness of nature.[35] Much the same tone was taken by Gustave Geffroy, another influential critic, in his introduction to Camille Pissarro's one-man show held in February 1890 at the Boussod et Valadon gallery, where Theo van Gogh had until very recently been manager.[36] Had Vincent lived longer, his work would have come to the attention of such critics whose sensibilities were closely attuned to modern painting's stylistic evocation of nature's harmonies and rhythms. As it was, his suicide preempted the critical support he might well have soon enjoyed.

FIG. 27. Georges Seurat. *Port-en-Bessin, les grues et la percée*. 1888. Oil on canvas, 25 ⅝ × 31 ⅞" (65.1 × 80.9 cm). National Gallery of Art, Washington, D.C. Gift of the W. Averell Harriman foundation in memory of Marie N. Harriman

FIG. 28. Vincent van Gogh. *The Starry Night*. 1889.
Ink over graphite on paper, 18 ½ × 24 ½" (47.1 × 62.2 cm).
Formerly Kunsthalle Bremen

Today the response *Starry Night* provokes is based in part upon its celebrity, but also on its universality. Throughout the ages people have been drawn to the night sky, to its stillness, sublimity, and infinitude, which together evoke in us emotions of peace and humility, awe and wonder. In *Starry Night* Van Gogh fused those feelings with a sense of the surging energies of terrestrial nature, which he conveyed—in the terms of his own style—with the confidence of his composition, the dynamism of his brush, and the resonance of his color. Painted from memories of observed experience, recollections of pictures seen long ago, and in creative competition with colleagues whose new work Van Gogh could only imagine, *Starry Night* is a painting made on the edge, by confidently taking risks. In isolation he created a work entirely and unforgettably in his own style.

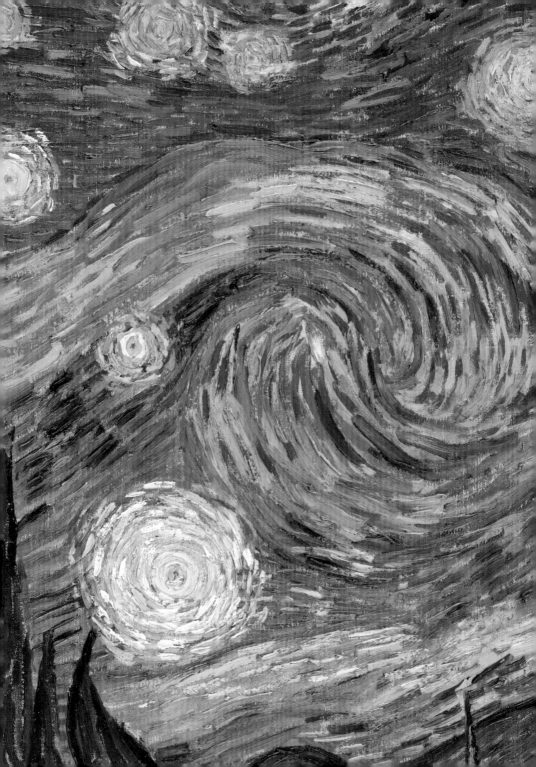

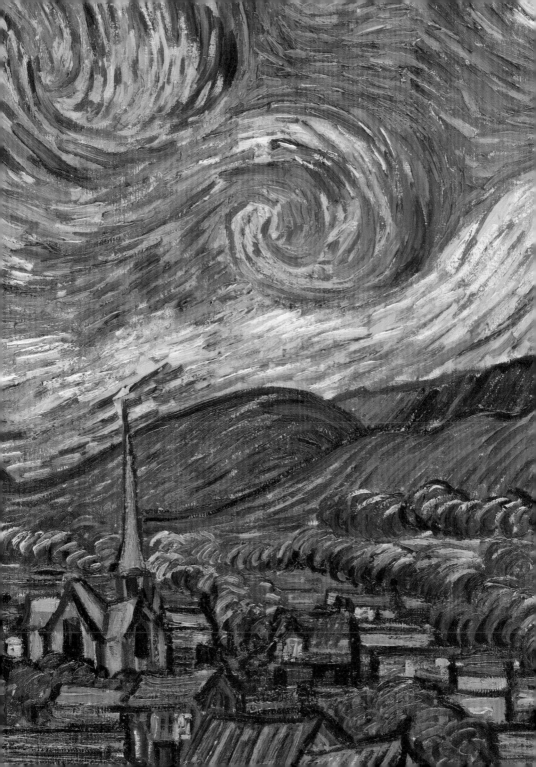

NOTES

1 See Leo Jansen, "Vincent van Gogh's Belief in Art as Consolation," in *Vincent's Choice: Van Gogh's Musée Imaginaire*, ed. Chris Stolwijk (Amsterdam: Van Gogh Museum, 2003), pp. 15–16; and Griselda Pollock, "On Not Seeing Provence: Van Gogh and the Landscape of Consolation, 1888–9," in *Framing France: The Representation of Landscape in France, 1870–1914*, ed. Richard Thomson (Manchester: Manchester University Press, 1998), pp. 103–08.

2 For the most recent overview of Van Gogh's career, see Belinda Thomson, *Van Gogh Painter: The Masterpieces* (Amsterdam: Van Gogh Museum, 2007).

3 For Van Gogh at Saint-Rémy, see Ronald Pickvance, *Van Gogh in Saint-Rémy and Auvers* (New York: The Metropolitan Museum of Art, 1986).

4 Ibid., p. 31.

5 Letter 594 [c. June 9, 1889], III, p. 180. Unless otherwise noted, references to Van Gogh's letters refer to *The Complete Letters of Vincent van Gogh*, 3 vols. (London: Thames & Hudson, 1958). Revised datings, noted throughout in brackets, are taken from Jan Hulsker, *Vincent van Gogh: A Guide to His Work and Letters* (Amsterdam: Van Gogh Museum, 1993). A new edition of the letters, thoroughly revised, will be published in 2009.

6 Letter 474 [April 9, 1888], III, p. 541.

7 Letter 543 [c. September 29, 1888], III, pp. 56–59.

8 Charles A. Whitney, "The Skies of Vincent van Gogh," *Art History* 9, no. 3 (September 1986): 354–55.

9 Berteaux's painting is illustrated in *Jeanne d'Arc: Les Tableaux de l'histoire, 1820–1920* (Rouen: Musée des beaux-arts, 2003), p. 135.

10 Letter 474 [April 9, 1888], III, p. 541.

11 Letter T9 [September 5, 1889], III, pp. 551–52.

12 Letter 593 [c. June 2, 1889], III, pp. 176–79.

13 Letter 594 [c. June 9, 1889], III, p. 179.

14 Letter W12 [June 16, 1889], III, p. 453.

15 Letter 595 [June 17 or 18, 1889], III, pp. 182–83.

16 I am grateful to Sjraar van Heugten for information about the phases and drying time.

17 Griselda Pollock and Fred Orton, *Vincent van Gogh: Artist of His Time* (Oxford: Phaidon, 1978), p. 66.

18 See Sven Lövgren, *The Genesis of Modernism: Seurat, Gauguin, Van Gogh, and French Symbolism in the 1880s* (Stockholm: Almqvist & Wiksell, 1959), p. 150; Meyer Schapiro, *Vincent van Gogh* (London: Idehurst Press, 1951), p. 33; and Lauren Soth, "Van Gogh's Agony," *Art Bulletin* 68, no. 2 (June 1986): 301–13.

19 Albert Boime, "Van Gogh's *Starry Night*: A History of Matter and a Matter of History," *Arts Magazine* 59, no. 4 (December 1984): 92–95; and Letter 511 [July 15, 1888], II, p. 615.

20 Whitney, "The Skies of Vincent van Gogh," pp. 356–59.

21 Letter 499 [c. June 4, 1888], II, p. 589; Letter W7 [c. September 8, 1888], III, p. 443.

22 Letter 520 [August 18, 1888], III, p. 6.

23 The church spire is often claimed to look more Dutch than Provençal (e.g., Pickvance, *Van Gogh in Arles*, p. 103), but the church at Saint-Rémy does actually have a spire, and Van Gogh's nostalgia for the north did not become apparent until later in his stay at the asylum.

24 Vincent van Gogh, *Painted with Words: The Letters to Emile Bernard*, ed. Leo Jansen, Hans Luijten, and Nienke Bakker (New York: The Morgan Library and Amsterdam: Van Gogh Museum, 2007), Letter 19 [c. October 5, 1888], p. 307.

25 Ibid., Letter 22 [c. November 26, 1889], pp. 339–40.

26 Letter 607 [September 19, 1889], III, p. 217.

27 Letter T18 [October 4, 1889], III, p. 553; the paintings were F. 611, either F. 712 or 622, and probably F. 512.

28 T10 [June 16, 1889], III, p. 544.

29 T19 [October 22, 1889], III, pp. 554–55.

30 Letter 613 [c. November 2, 1889], III, p. 227.

31 Douglas Cooper, ed., *Paul Gauguin: 45 Lettres à Vincent, Théo et Jo van Gogh* (Amsterdam: Van Gogh Museum, 1983), p. 344.

32 The two 1889 letters are Van Gogh, *Painted with Words*, Letters 21 and 22.

33 G.-Albert Aurier, "Les Isolés: Vincent van Gogh," *Mercure de France* (January 1890), in *Albert Aurier: Textes critiques, 1889–1892*, ed. Denis Mellier, Marie-Karine Schaub, and Pierre Wat (Paris: Ecole des Beaux-Arts, 1995), pp. 67, 72.

34 Octave Mirbeau, "Vincent van Gogh," *L'Echo de Paris*, March 31, 1891, in *Octave Mirbeau: Des Artistes*, ed. Hubert Juin (Paris: Union Générale d'Editions, 1986), p. 138.

35 Octave Mirbeau, "Claude Monet," in *Claude Monet. A. Rodin* (Paris: Galerie Georges Petit, 1889), pp. 5–26.

36 Gustave Geffroy, "Camille Pissarro," in *Exposition des oeuvres récentes de Camille Pissarro* (Paris: Boussod, Valadon et Cie., 1890), pp. 5–12.

Aurier, G.-Albert. "Les Isolés: Vincent van Gogh." *Mercure de France* (January 1890). Reprinted in Albert Aurier, *Textes critiques, 1889–1892*, edited by Denis Mellier, Marie-Karine Schaub, and Pierre Wat. Paris: Ecole des Beaux-Arts, 1995, pp. 66–73.

Berge, Jos ten, Teio Meedendorp, Aukje Vergeest, and Robert Verhoogt. *The Paintings of Vincent van Gogh in the Collection of the Kröller-Müller Museum*. Otterlo, The Netherlands: Kröller-Müller Museum, 2003.

Boime, Albert. "Van Gogh's *Starry Night*: A History of Matter and a Matter of History." *Arts Magazine* 59, no. 4 (December 1984): 86–103.

Cooper, Douglas, ed. *Paul Gauguin: 45 Lettres à Vincent, Théo et Jo van Gogh*. Amsterdam: Van Gogh Museum, 1983.

Druick, Douglas W., and Peter Kort Zegers. *Van Gogh and Gauguin: The Studio of the South*. Chicago: The Art Institute of Chicago, 2001.

Geffroy, Gustave. "Camille Pissarro." In *Exposition des oeuvres récentes de Camille Pissarro*, pp. 5–12. Paris: Boussod, Valadon et Cie., 1890.

Gogh, Vincent van. *Painted with Words: The Letters to Emile Bernard*, edited by Leo Jansen, Hans Luijten, and Nienke Bakker. New York: The Morgan Library and Amsterdam: Van Gogh Museum, 2007.

Jansen, Leo. "Vincent van Gogh's Belief in Art as Consolation." In *Vincent's Choice: Van Gogh's Musée Imaginaire*, edited by Chris Stolwijk et al., pp. 13–24. Amsterdam: Van Gogh Museum, 2003.

Jirat-Wasiutynski, Voytech. "Van Gogh's Paintings of Olive Trees and Cypresses from Saint-Rémy." *Art Bulletin* 75, no. 4 (December 1993): 647–70.

Lövgren, Sven. *The Genesis of Modernism: Seurat, Gauguin, Van Gogh, and French Symbolism in the 1880s*. Stockholm: Almqvist & Wiksell, 1959.

Mirbeau, Octave. "Claude Monet." In *Claude Monet. A. Rodin*, pp. 5–26. Paris: Galerie Georges Petit, 1889.

———. "Vincent van Gogh." *L'Echo de Paris*, March 31, 1891. Reprinted in *Octave Mirbeau: Des Artistes*, edited by Hubert Juin, pp. 130–37. Paris: Union Générale d'Editions, 1986.

Pickvance, Ronald. *Van Gogh in Arles*. New York: The Metropolitan Museum of Art, 1984.

———. *Van Gogh in Saint-Rémy and Auvers*. New York: The Metropolitan Museum of Art, 1986.

Pollock, Griselda, and Fred Orton. *Vincent van Gogh: Artist of His Time*. Oxford: Phaidon, 1978.

Pollock, Griselda. "On Not Seeing Provence: Van Gogh and the Landscape of Consolation, 1888–9." In *Framing France: The Representation of Landscape in France, 1870–1914*, edited by Richard Thomson, pp. 81–118. Manchester: Manchester University Press, 1998.

Schapiro, Meyer. *Vincent van Gogh*. London: Idehurst Press, 1951.

Soth, Lauren. "Van Gogh's Agony." *Art Bulletin* 68, no. 2 (June 1986): 301–13.

Thomson, Belinda. *Van Gogh Painter: The Masterpieces*. Amsterdam: Van Gogh Museum, 2007.

Uitert, Evert van, Louis van Tilborgh, and Sjraar van Heugten. *Vincent van Gogh: Paintings*. Amsterdam: Van Gogh Museum, 1990.

Whitney, Charles A. "The Skies of Vincent van Gogh." *Art History* 9, no. 3 (September 1986): 351–62.

ACKNOWLEDGMENTS

No book of this kind can be written without recourse to
the work of many scholars, and I would like to express my thanks
generally to earlier and contemporary scholars of Van Gogh's
work. It is always a pleasure to work in parallel with my friends
at the Van Gogh Museum, Amsterdam, and I particularly
thank Axel Rüger, Sjraar van Heugten, Chris Stolwijk, Louis van
Tilborgh, Leo Jansen, Ella Hendricks, Nienke Bakker, and
Hans Luijten. At The Museum of Modern Art I am grateful,
for their various encouragement and support, to John Elderfield,
Chris Hudson, Kara Kirk, David Frankel, Libby Hruska,
Christina Grillo, and Hannah Kim, and to designer Roy Brooks.
I walk this enchanted ground with my wife, Belinda.

quired through the Lillie P. Bliss Bequest, this
Museum.

Van Gogh's "Starry Night"

"A star spangled sky . . . that's a thing I would like to try to do." So wrote van Gogh to his friend Emile Bernard in the spring of 1888. For months afterwards the problem obsessed him until, finally, in June 1889 he painted *The Starry Night* recently acquired by the Museum.

The Starry Night is not only one of van Gogh's most moving and beautiful pictures. It has also a particular interest, for it was painted during a critical turning point in his art and in his life.

In May 1889 van Gogh, who had suffered two attacks of what we today would probably call manic depression, was sent to the sanatorium of St. Rémy, near Arles, by his devoted brother Theo. *The Starry Night* was among the first half dozen canvases completed in these new and disquieting surroundings. But its style is the result not so much of psychological crisis as of a long delayed emergence of the artist's ability to express his strongest and deepest emotions through painting.

For over a year van Gogh's art had been a battleground between fact and feeling, between objective realism and imaginative vision, between Impressionism and what was later to be called Expressionism. Van Gogh had been a devout Impressionist under the tutelage of Pissarro and Seurat, but in 1888 he began to respond to the liberating influence of his friends Gauguin and Bernard who upheld the right of the artist to paint from his imagination without regard to realism. This influence was countered by Theo van Gogh who was loyal to Impressionism and wanted his brother to stick to facts. Theo did not like *The Starry Night* or other paintings in the St. Rémy style.

But it is in the paintings of St. Rémy with their flamboyant cypresses and heaving mountains that van Gogh's art culminates, and of this culmination *The Starry Night* is possibly the purest and most complete expression. For more than any other van Gogh it is not so much a transformation of reality as fundamentally an imaginative invention. The swirling sky, the sun-bright moon, the milky way turned to comets, the exploding stars—these reveal the unique and overwhelming vision of a mystic, a man in ecstatic communion with heavenly forces.

In this sense *The Starry Night* may well take its place among the few great religious paintings of the past hundred years. Van Gogh might have denied this for the passionate evangelical Christianity of his youth had turned to bitter disillusionment (leaving intact only the figure of Christ himself whom he called "the greatest artist"). But to the subject of *The Starry Night*, which he wrote had "haunted" him always, van Gogh attached a special significance. In a letter to Theo after discussing the problem of painting a street scene in the spirit of the realistic novelists, Flaubert and Zola, he writes, "that does not prevent me having a terrible need of—shall I say the word—religion. Then I go out to paint the stars . . ."

B.

3

The Bulletin of The Museum of Modern Art, 1941, showing the Museum's new acquisition, through the Lillie P. Bliss Bequest, of Vincent van Gogh's *The Starry Night*, 1889

VINCENT VAN GOGH (1853–1890)

THE PAINTINGS OF VINCENT VAN GOGH HOLD AN ENDURING FASCINATION for art audiences everywhere, and perhaps none more so than *The Starry Night* (1889), which depicts the dramatic whorls and restless energy of a night sky in Provence. Van Gogh had left the frenzy of Paris for Provence in 1888, telling his brother Theo he was in search of "a different light." Indeed, the bright colors and intense climate of southern France had a profound impact on his art, resulting in his turning away from the somber palette he had used in depictions of peasants and rural life earlier in his career.

Van Gogh was born in 1853 in the southern Netherlands, the second of six children. He did not turn to art until 1880, following forays working for an international art dealer, teaching, and working as a missionary. In 1885 he left The Netherlands—he would never again return to his native land—first for Antwerp, then the following year for Paris. This was a time of artistic awakening for Van Gogh. He discovered new materials and had access to models and art classes; in Paris he met contemporaries who would prove to be influential, including Paul Gauguin, Henri de Toulouse-Lautrec, and Camille Pissarro, and he began experimenting with new styles and approaches to color.

Despite these broadening horizons, Van Gogh found the bustle of the French capital to be too much. In early 1888 he left for Arles. After struggling with recurring bouts of mental illness, he spent the early months of the following year in the public hospital there, and in May 1889 checked himself into the Saint-Paul-de-Mausole asylum in Saint-Rémy, a small town not far from Arles. It was here that he painted *The Starry Night*, as envisioned from the confines of his room. Though the artist himself was not entirely satisfied with it, this magical work, which entered MoMA's permanent collection in 1941, retains a special place in the imaginations of all who view it.

PHOTO CREDITS

This publication was made possible by the Dale S. and Norman Mills Leff Publication Fund.

Produced by the Department of Publications
The Museum of Modern Art, New York
Edited by Libby Hruska
Designed by Roy Brooks, Fold Four
Production by Christina Grillo

Printed and bound by Oceanic Graphic Printing, Inc., China
Typeset in FF Kievit
Printed on 140 gsm Gold East Matte Artpaper

INSIDE FRONT COVER: Maps from Johnson's New Illustrated Family Atlas, 1862. Courtesy the University of Alabama Map Library

INSIDE BACK COVER: Detail of map from Johnson's New Illustrated Family Atlas, 1862. Courtesy the University of Alabama Map Library

PP. 39–40: Details of Vincent van Gogh's *The Starry Night*. 1889. See p. 2

Library of Congress Control Number: 2008930317
ISBN: 978-0-87070-748-3

Published by The Museum of Modern Art
11 West 53 Street, New York, NY 10019-5497
www.moma.org

Distributed in the United States and Canada by D.A.P./Distributed Art Publishers, Inc., New York

Distributed outside the United States and Canada by Thames & Hudson, Ltd, London

Printed in China